Markers and Pens

There are so many pens on the market that it can be overwhelming choosing the ones that are best for you to use.

For this book I grabbed pens from my stash, asked friends what they liked and used pens that were easily available from my local stores.

All the pens worked great. There are a few differences that you may consider when choosing pens for your use.

For scrapbooks and journals, you'll want the ink to last for a long time. Look for the words "archival" and "lightfast". Permanent means the ink won't run when touched by water. When in doubt, check the internet or contact the manufacturer. Since the surface of a pen is small, it is difficult to print all the information on the barrel.

For doodling, I choose my pens based upon the tip. I like to have at least three tip styles handy.

For the first long freehand scroll marks, I prefer the Pitt Brush tip. It gives me a varied line quality that looks lovely.

For finer lines, scrolls, and templates, I prefer a Fine tip pen. The 0.3mm, 0.5mm, and 0.7mm are all good. For general use, the 0.5 seems the most versatile.

For dots, a Bullet tip is the easiest. Just press for an instant large dot...fast and easy.

Permanent ink and India ink available from Pitt, Alvin, Sharpie, and Uni-ball Signo will usually write directly on photos.

One final tip: Store pens horizontally to help keep the ink juicy.

Suzanne McNeill

Break out of the usual journaling b[] write directly onto a photo with a perm[] pen. Anything done in your own hand i[] going to be treasured by loved ones, so [] the process. Look for open spaces on y[] photos and fill them with special memories.

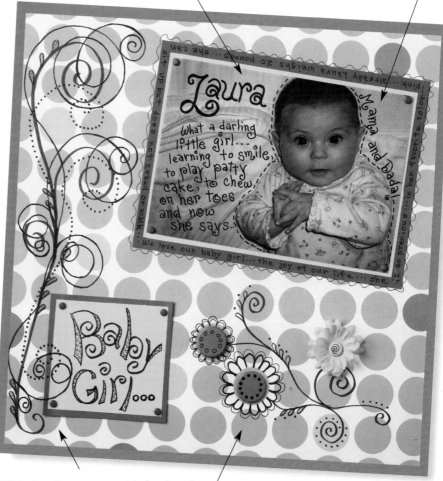

[]shed line border around the photo subject draws your eye.

'Laura' scrapbook page
Decorative papers are from *Pebbles Inc.*

Fill in border spaces with freehand swirls, stitching, word captions, or anything else that fits your theme.

Just for fun, enhance the shapes on your patterned papers. The dots on this page have blossomed into beautiful flowers.

Of course, you don't have to do everything on one page. Pick and choose the elements that work best for you and have fun.

Don't try to make your doodles perfect. The whole point of doodling is to escape the machine-made pre-processed environment and get back to the joys of works formed by the human hand.

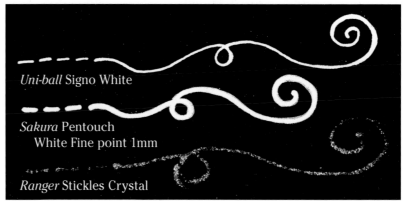

Uni-ball Signo White

Sakura Pentouch
White Fine point 1mm

Ranger Stickles Crystal

Faking Freestyle

by Emily Adams

Freestyle is an "anything goes" approach to scrap-booking. The term conjures up images of wild and impressive doodling techniques that I've seen in magazines and online.

I love the look, but when it comes to putting pen to paper, I tend to stall. It's hard to be creative "on demand". Often, I'm in the mood to doodle but don't know where to begin.

These techniques can be a great "warm up" to get you comfortable with doodling because they are easy to do and consistently produce great results.

There is no need to reinvent the wheel, so when you are working with patterned paper, let the patterns inspire you to develop designs that interest you.

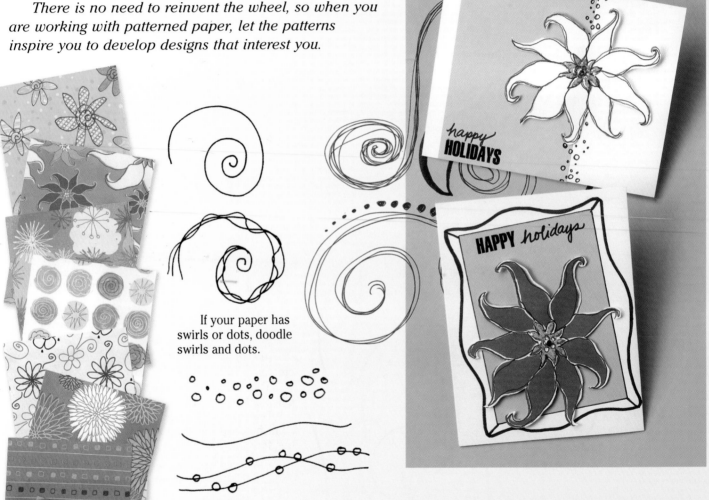

If your paper has swirls or dots, doodle swirls and dots.

If your paper has a stripe, echo the design with lines or dots. Doing so gives cohesiveness to your layout and provides a starting point for further doodles.

Another technique involves tracing around the patterns in the paper itself with lines or dots. For example, draw a circle around a polka dot. Trace the edge of each letter in a printed word. These small touches make a huge impact, giving a natural freestyle look.

Emily Adams

Emily is the Education Director for Imagination Project, the artist behind their product line, Circus Rose, and co-designer of Project Essentials. She has been a CKU professor since 2002 and teaches all over the United States, as well as internationally. Her classes are available online through CKU Home Study.

Emily has been published in Memory Makers, CK, Scrapbooks Etc., and Scrapbook Insider and has been featured on ten DIY Scrapbooking episodes.

In 2006, she launched her own website, www.EmilyAdamsOnFire.com and newsletter (Playing With Fire) to share her ideas and creations.

Doodling on Cards

When making the Christmas cards to the left, I started with a sheet of patterned paper. I traced all the lines on the poinsettia with a Black marker and was surprised at how much that made the design "pop". Then I cut them out and mounted them on cards.

The doodles were inspired by the poinsettias. On the Green card, I drew curved lines and added the circles from the flower center. On the card with the White flower, I simply repeated the circles in varying sizes covering the paper seam. On the last card, I wanted a frame. Drawing the beveled lines first, it was a snap to connect wavy lines to form the frame.

Decorative papers are from *Chartreuse Dream*.

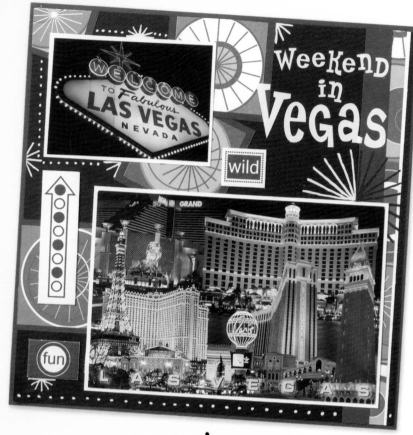

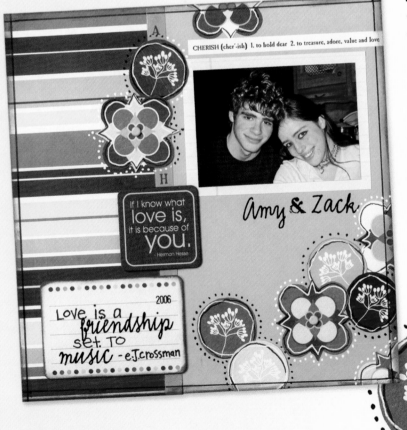

Weekend in Vegas page

I repeated the asterisk design from the paper all over the scrapbook page. The lights around the Welcome sign inspired the dots around the photos.

Decorative papers are from *Gin-X*.

Amy & Zack scrapbook page

Another way to use patterned paper to inspire creative doodling is found in the Amy & Zack page.

Trace the edges of a design with Black and White pens. Cut out and adhere to page.

Dot around the edge to emphasize the design. As a finishing touch, use a ruler to line the outside border, then ink the edges.

Decorative papers are from *Gin-X*.

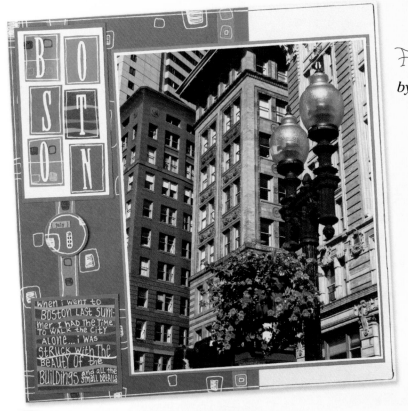

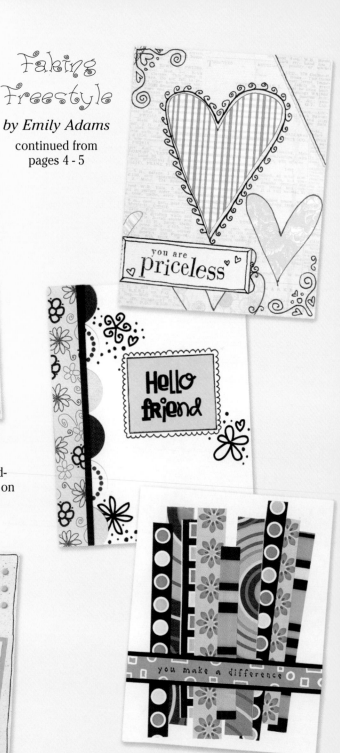

Boston scrapbook page

The squares in the paper reminded me of the windows in the buildings. Using a White pen, I echoed the squares randomly and journaled on the wavy stripe paper.

Decorative papers are from *Chartreuse Dream*.

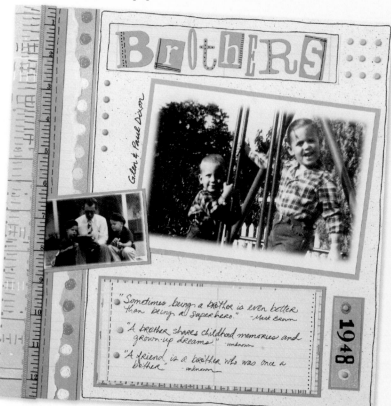

Brothers scrapbook page

The random lines. dashes, and dots in the paper made adding handdrawn accents a breeze. The page has a modern, masculine feel that does not compete with the vintage photos. Dots and lines draw attention to the title.

Decorative papers are from *Chartreuse Dream*.

Priceless card

Add drama to a layered design with little curls. Heart-shaped scrolls carry the theme to the corners for a beautifully balanced card.

Decorative papers are from *Blue Cardigan Designs*.

Hello Friend card

Punched circles create a unique scalloped border. Doodle rub-ons provided the basis for the handwork.

Decorative papers are from *Gin-X*.

You Make a Difference card

Create a great design with strips of cotton art tape or leftover cardstock. Just echo some of the patterns on the strip that bears the card sentiment.

Decorative papers are from *Center City Designs*.

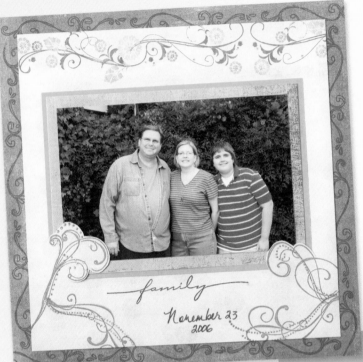

family

November 23
2006

by Donna Goss
Several manufacturers produce stamps with doodle designs. Use them to accent your photos and pages. Take doodling with stamps to the next level with glitter glue, rhinestones, or brads.

Autumn Leaves stamps, ColorBox ink, Ranger Stickles glitter glue

Doodling with Rub-Ons

by Andrea Gibson
Rub-ons give a projects delicate details. Make them sparkle by adding adhesive rhinestones and pearls.
Create a unique border strip or title bar by cutting around the edge of the rub-on.

Rub-ons by Basic Grey.

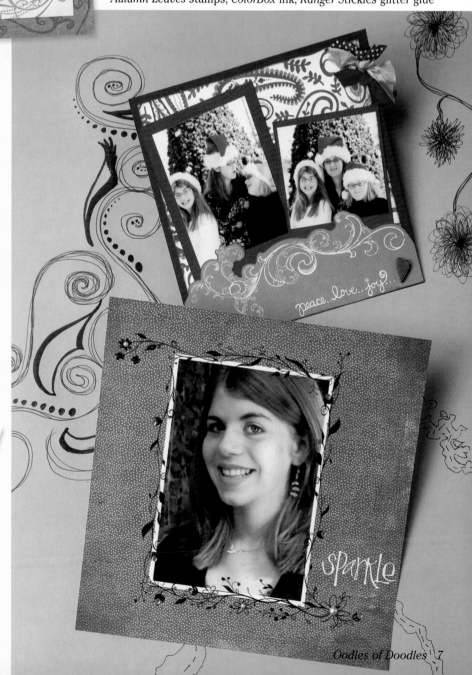

peace..love..joy...

sparkle

Doodling with Stickers

by Andrea Gibson

There are many ways to embellish a sticker with doodles. The simplest is to doodle around the edge or within the letter itself. You will be amazed at how easy it is to add a special accent to all sorts of stickers including letters and some of my favorites - flowers.

Check out these examples for ideas that will get your imagination started.

Stickers from *Stickopotamus*, *Creative Imaginations*, *The Paper Studio*, and *Sandylion*.

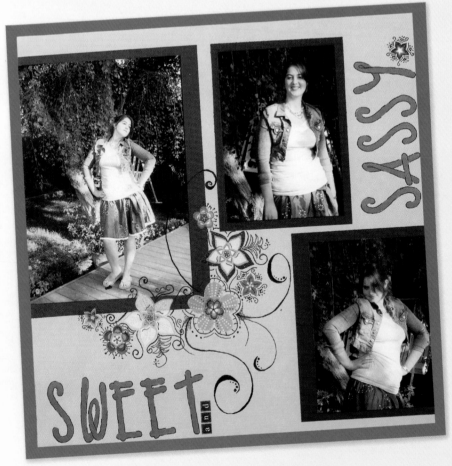

Sweet and Sassy scrapbook page

Give your page a sweet and sassy flair. Add fast and fabulous flourishes with to these easy-to-use flower stickers. Place the flower sticker grouping on layout, then doodle around to expand your design flair.

Alphabet Stickers with Doodling

Personalize alphabet stickers by adding fun and fabulous doodles.

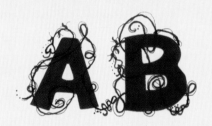

Doodling with a Hot Marks Tool

by Donna Goss

Using a light touch, trace, doodle around, or write on the glossy photo using the heated Hot Marks tool.

As an option, you can stamp on the photo and accent the image with the tool.

The tool also works on glossy cardstock.

Tip: *You will get better results with the hot marks tool if you use the same brand glossy photo paper as your home printer.*

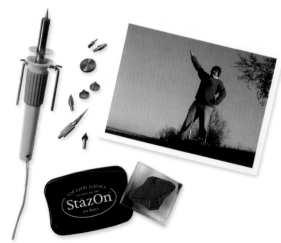

Walnut Hollow Hot Marks tool, *Tsukineko* StazOn ink, *Green Pepper Press* rubber stamp, Glossy photo

Doodling with Templates

Do you feel like you can't draw? Templates will convince you that you can. Just choose your design and pen, position the template, and Wow! You can create all kinds of designs in no time. Using a template will build your confidence in your freehand skills too.

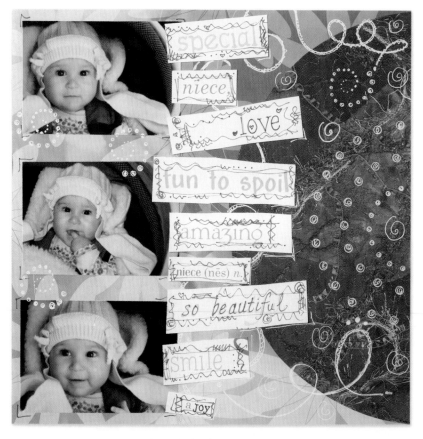

Jaime Echt

Jaime has been teaching and crafting for the past 20 years. She loves portrait photography and finds that scrapbooking allows her to combine her photographic interests with her passion for beautiful papers.

Jaime designs papers and templates for The Crafter's Workshop. You can see more of her designs or contact her at www.TheCraftersWorkshop.com.

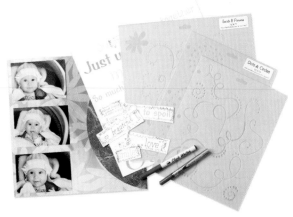

Special Niece page

Doodling around pre-printed words makes them stand out and adds another interesting element to the design. Don't neglect your colored markers. I used a lot of White pens to doodle on this page.

Templates and papers by *The Crafter's Workshop*, *Sanford* Uni-ball Signo White pen, *American Crafts* Slick Writer Fine point

1. Draw boxes, zigzags, lines and dots around the words that best suit your layout.

2. Cut out each box and glue in place.

3. Using a White pen, trace the doodles onto the layout. Hold the template with one hand while tracing. White pen dries slowly. Lift the template carefully to avoid smudges.

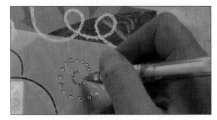

4. Continue doodling by adding swirls and dots. Allow each addition to dry to avoid smudges.

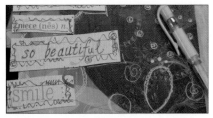

5. Here is an example of how the doodles look. When using a White pen, don't doodle over the same area too often for you can scrape off your previous work.

6. To finish, add little "L" corners to the word boxes with a White pen.

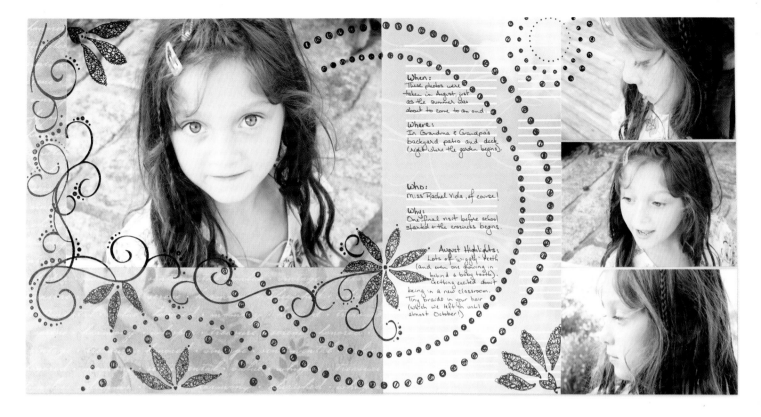

Beauty page

by Jaime Echt

Bring focus to your photograph by framing it with flowing curved doodles. Templates make it easy to personalize your page. Dots of different sizes and curling swirls inside the leaves provide the changes in scale that make a design interesting to the eye. Give your work a more organic look by filling the circles only partially with varying strokes.

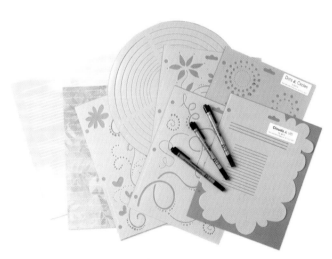

Templates and papers by *The Crafter's Workshop,* *Alvin* Penstix black pens

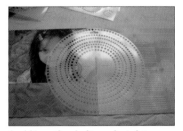

1. Align the left and right sides of the layout. Place the Dots all Around template exactly in the middle of the two pages.

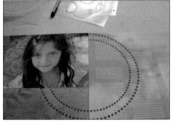

2. Use the 0.7mm Penstix pen to copy the concentric circles onto both sheets. Don't worry about filling them in perfectly.

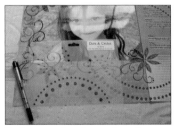

3. Create the dotted arches below the photo.

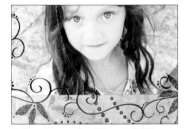

4. Position the Floral & Vines template over the large portrait.

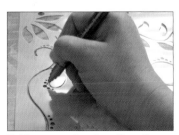

5. To trace the doodles, first outline, then fill in.

6. To create leaves, trace the outline and make swirls inside the design.

Doodling with Templates

Templates are particularly appealing to those of us who are timid about freehand work. Playing with a template will increase your confidence and lead you to even more adventurous doodling.

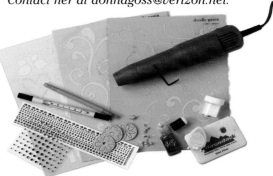

Donna Goss

Donna is an innovative and energetic multi-media artist. She has created stamp art since 1992. Her talent repertoire includes soldering, collage, scrapbooking, beading, jewelry, and metalwork.
She works at the Stamp Asylum in Plano, Texas. Contact her at donnagoss@verizon.net.

Line Work: Decorate around photos and layout edges using pens to draw lines. Accent with squiggles, cross hatch marks, and dots to dashes.

Use the lines for journaling to create a great look.

Chatterbox templates and markers, *EK Success* Zig marker, *Ranger* Adirondack dye ink and Stickles glitter glue, *Tsukineko* Versa Magic chalk ink and dauber, *K&Company* Adhesive Rhinestones, *Stampendous* Class A Peels stickers, Heat gun, Embossing powder, Chipboard shapes, Brads, Eyelets

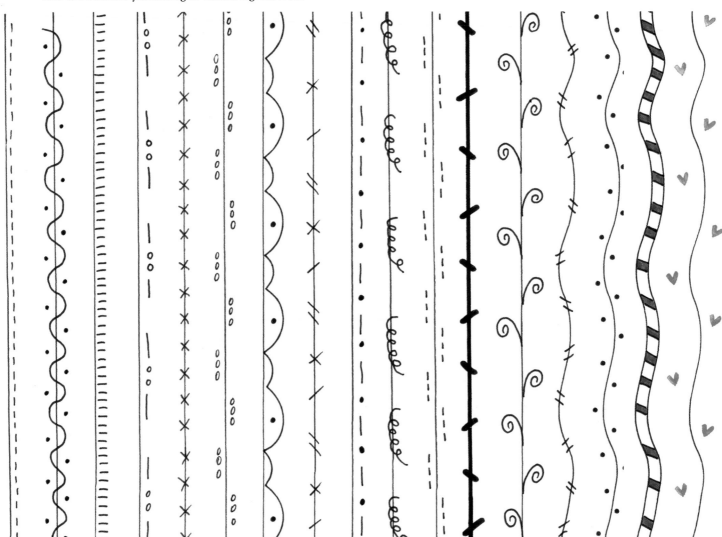

Borders: Some templates have one edge with a decorative border. Use it with stamps and pens of varying thicknesses as well as stickers, rhinestones, brads, and glitter glue. You can also line up the designs on the templates as borders.

Shapes: Accent shapes on template with stickers or glitter glue. Color them in with markers, pencils, or inks. Combine several shapes to create your own combinations.

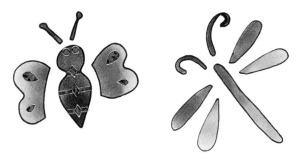

Butterfly and Dragonfly: Sponge ink inside a template. Doodle the accents and antennae.

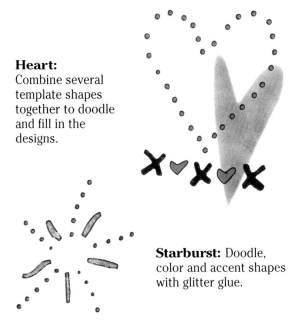

Heart:
Combine several template shapes together to doodle and fill in the designs.

Starburst: Doodle, color and accent shapes with glitter glue.

Swirls: Color in the swirls using the same technique explained in Shapes. Add brads and chipboard for a fun combo. Jazz up the designs with rhinestones.

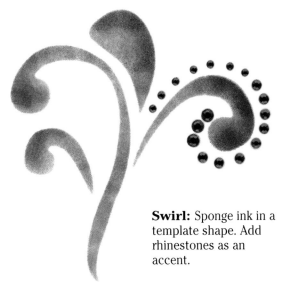

Swirl: Sponge ink in a template shape. Add rhinestones as an accent.

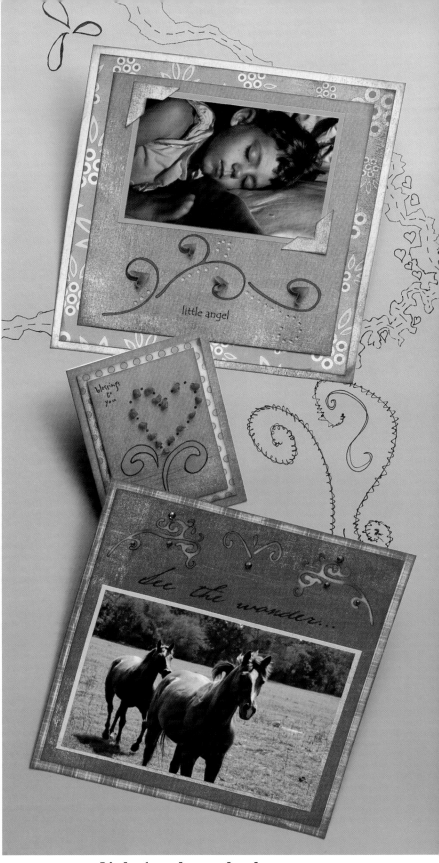

Little Angel scrapbook page
Trace swirls using template. Color with marker. Punch holes where the dots are. Layer contrasting cardstock so it shows through the holes.

Heart Flower card
Trace stencil for stems. Sponge pigment ink inside and emboss with Clear powder. Trace the dotted heart stencil for flower. Punch holes in every other dot. Tie a knot in the middle of 3" of ribbon. Pull ribbon tails through holes to back of card. Tape tails on back.

See the Wonder scrapbook page
Trace swirls using template. Sponge pigment ink inside and emboss with Clear powder. Add rhinestones.

Doodling with Chipboard

Pre-cut chipboard is easily available and inexpensive. This versatile medium is begging to be painted, stamped, covered, and doodled!

Chip-sie Doll
Embellish the body with *Petaloo* flower petals and a 1" *Bazzill* brad for the head. Add doodles.

Design Originals Chipsie Doll body,
Fancy Pants large chipboard,
Deluxe Designs chipboard shapes

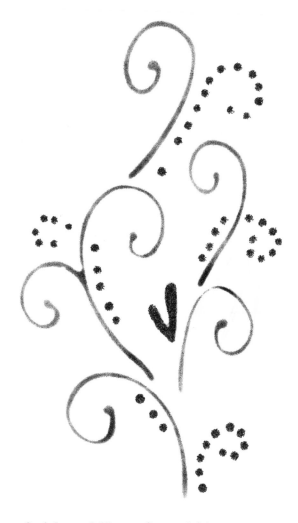

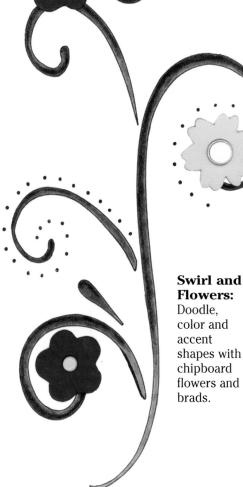

Swirl and Flowers:
Doodle, color and accent shapes with chipboard flowers and brads.

Swirls and Heart: Sponge ink in a template shape. Doodle, color and accent shapes with glitter glue.

Decorative papers are from *Basic Grey, Design Originals* and *WorldWin*

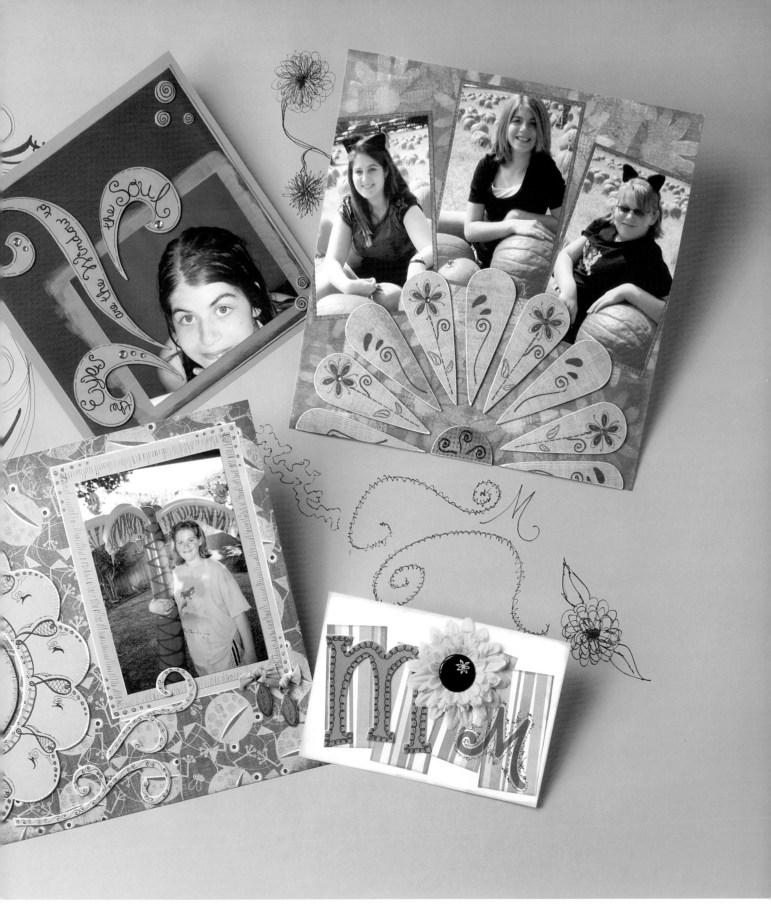

Swirls 8" page

Next time you need a dimensional embellishment, remember this technique. Cut out chipboard shapes, add a little paint, a doodle outline, and rhinestones for an inexpensive yet sparkling effect.

Frogs 12" page

Paint die-cut chipboard in colors that coordinate with your layout. You are now ready to doodle!

Pumpkins 12" page

Cover a chipboard petal with paper. Use stamps to create the doodles on the petals. Add additional drawn doodles and rhinestones to complete this beautiful look.

Mom card

Chipboard letters are perfect for doodling. Add a doodled outline around your rub-on letter for a fancy, complete look.

Doodling with ABC Templates

Andrea Gibson

I love making things with my hands and sharing my ideas with others. I hope these doodles inspire your creativity. I currently design layouts, cards and jewelry as well as instruct for Artistic Wire.
You can contact me at andreagibson@earthlink.net.

Doodling is a popular technique with paper crafters and scrapbookers nationwide. If you are not a natural doodler and want to practice, these examples using alphabet stencils are a perfect place to begin. You don't have to doodle a whole word.

Try doodling just the first initial of a name. Believe me, when you accomplish one and discover how much fun it is, you will become an addicted doodler.

Fiskars Shape Template letters, *Wordsworth* Fancy Caps Template, *Alvin* Black Ultra Fine tip marker

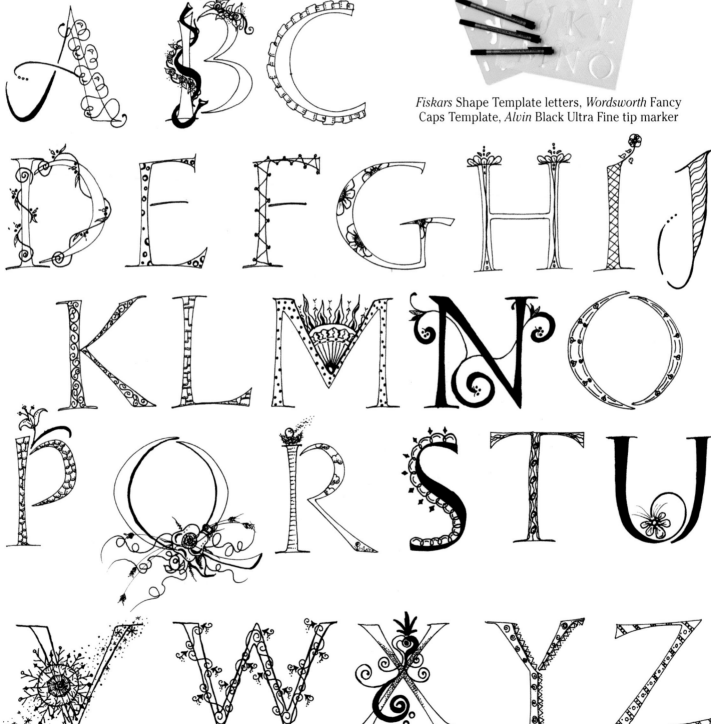

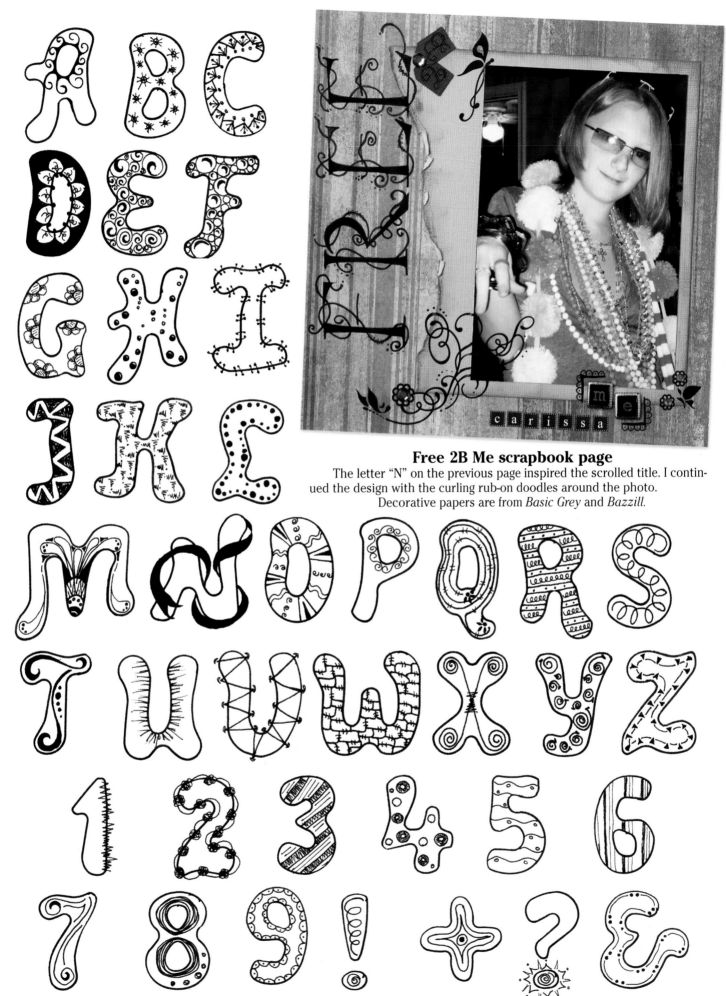

Free 2B Me scrapbook page
The letter "N" on the previous page inspired the scrolled title. I continued the design with the curling rub-on doodles around the photo.
Decorative papers are from *Basic Grey* and *Bazzill.*

Freehand Doodling

If you are one of the many people who want to doodle but hesitate when the pen nears the page, this lesson was designed for you. So many scrapbookers say, "I just don't want to mess it up. What if I make a mistake?"

First, know that there are no mistakes. Turn an ink blob into a filled-in circle; a stray mark into an ornate swirl or dotted pattern. Below are examples to get you started.

Need more ideas? Have you ever noticed the design on expensive ironwork or looked at motifs carved on buildings? Take a look at the patterns in your kitchen floor tile. Many of these simple designs are easily reproduced in doodles.

Tonya Bates

Tonya spends her time creating crafts and fine arts. She enjoys paper crafting, painting, sculpting, ceramics, drawing, decorating, and playing the piano. Many of Tonya's beautiful designs have appeared in books by Leisure Arts. You can reach her at
tonya_bates@hotmail.com

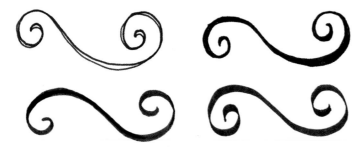

Begin by lightly drawing a simple swirl with a pencil. Then trace over it with a marker.

Draw flowing curves first. Then enhance the design with dots.

Draw the simple swirl. Then add a shadow. Use a pen to trace and fill in the thicker areas.

Loops and curls are easy to trace. Draw them with a pencil first. You can erase it if you don't like it.

Accent the outside curve of a swirl with a scallop. Add dots for a lacy look.

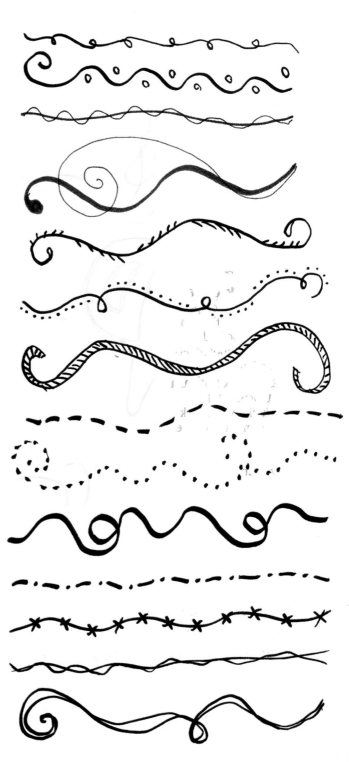

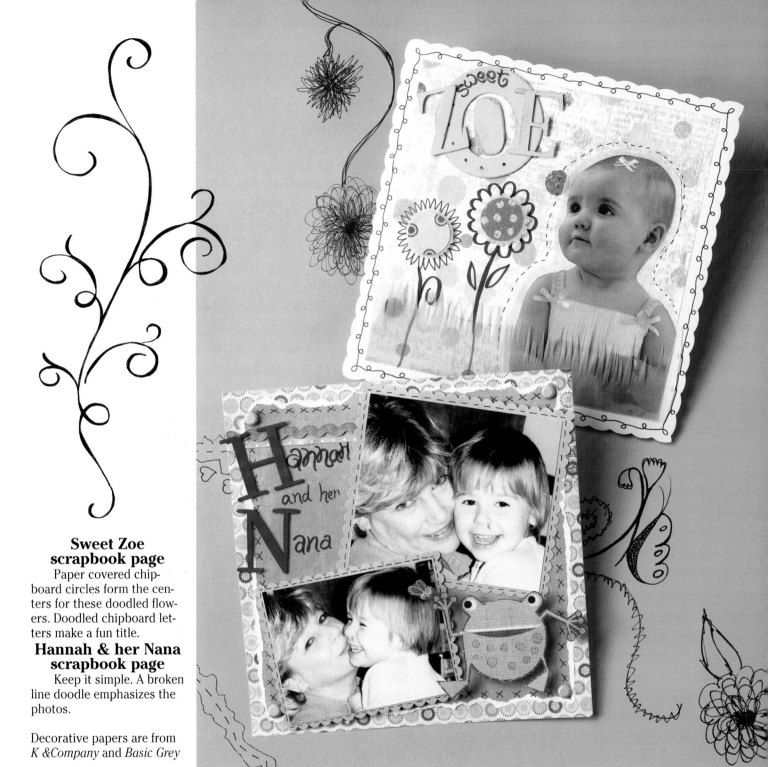

Sweet Zoe scrapbook page
Paper covered chipboard circles form the centers for these doodled flowers. Doodled chipboard letters make a fun title.

Hannah & her Nana scrapbook page
Keep it simple. A broken line doodle emphasizes the photos.

Decorative papers are from *K &Company* and *Basic Grey*

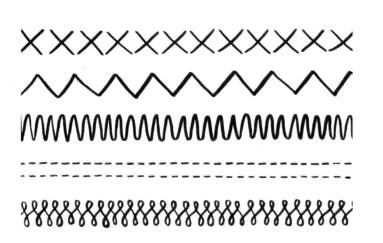

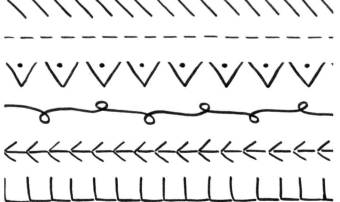

Freehand Doodle Borders for Any Shape
by Tonya Bates
Creating borders around shapes draws attention to them and brings them to life. Here are a few examples to fuel your imagination and get you started.

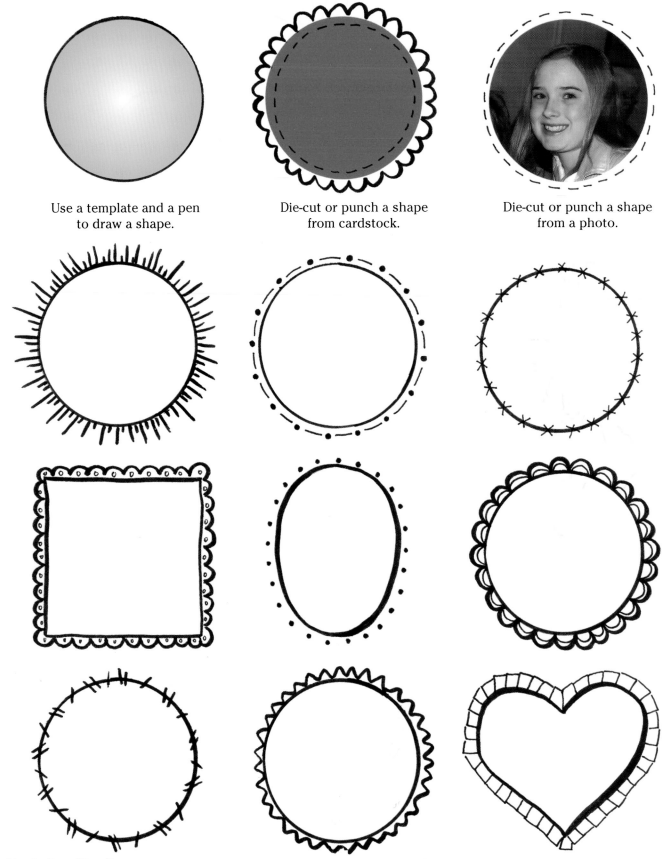

Use a template and a pen to draw a shape.

Die-cut or punch a shape from cardstock.

Die-cut or punch a shape from a photo.

Draw a freehand shape
with a pen.

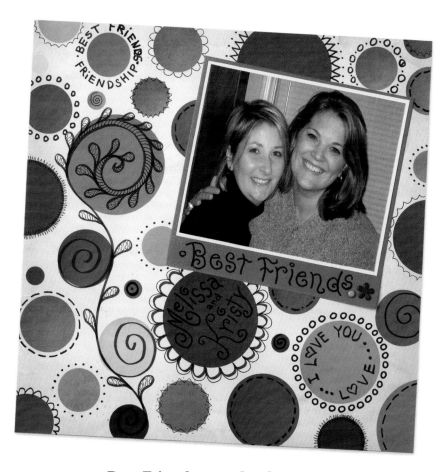

Best Friends scrapbook page

Purchase an extra sheet of paper to play with and work out your design. Nearly every circle has a doodle. You don't have to doodle every one, but once you get started, it's sometimes difficult to stop!

Decorative papers are from *American Crafts*.

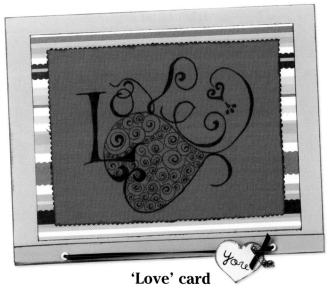

'Love' card

Who says everything must be right side up? Turn a heart on its side and use the edge as your line for doodling the "love" letters. The heart is filled with scrolled doodles.

Freehand Leaves and Flowers

by Tonya Bates

Doodling is a very basic form of artistic expression. Many paper crafters are turning their pens and imaginations into unique embellishments.

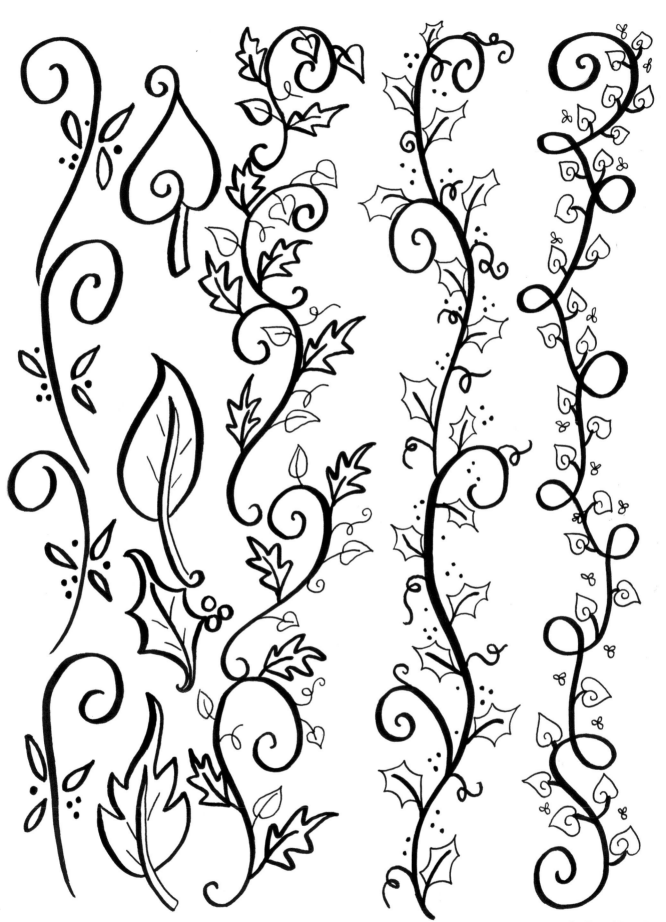

Freehand Flights of Fancy
by Tonya Bates

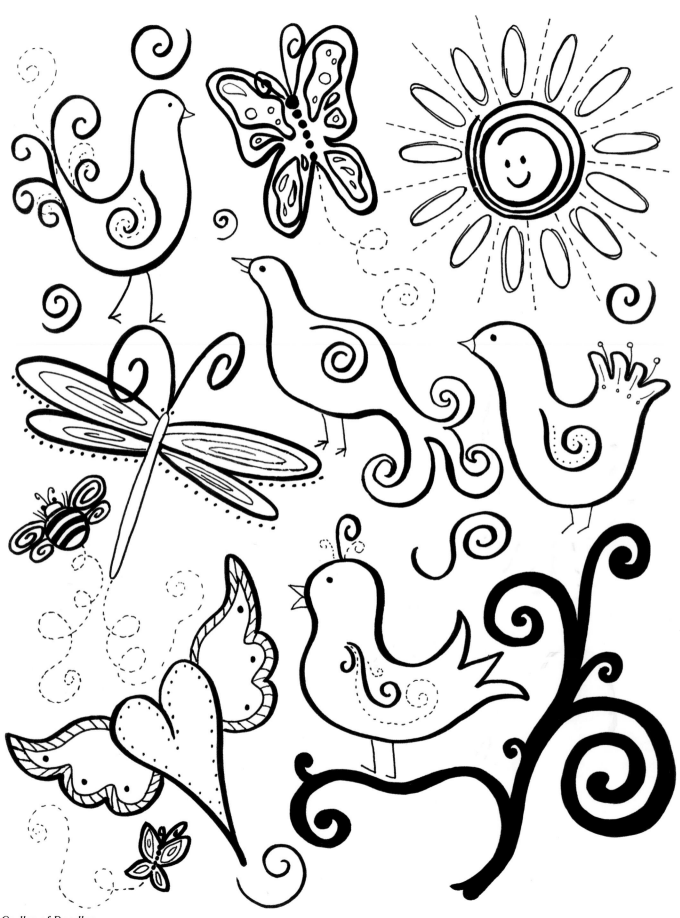

Graceful curves give these designs a beauty all their own. Practice doodling a few of these on scrap paper, or if you are timid about your drawing ability, begin by tracing the designs. Then draw one on your own. Remember, these are not photocopies! They are not supposed to look exactly alike. Each doodle is as unique as your signature. Break out the crayons, markers, pens and pencils and have fun!

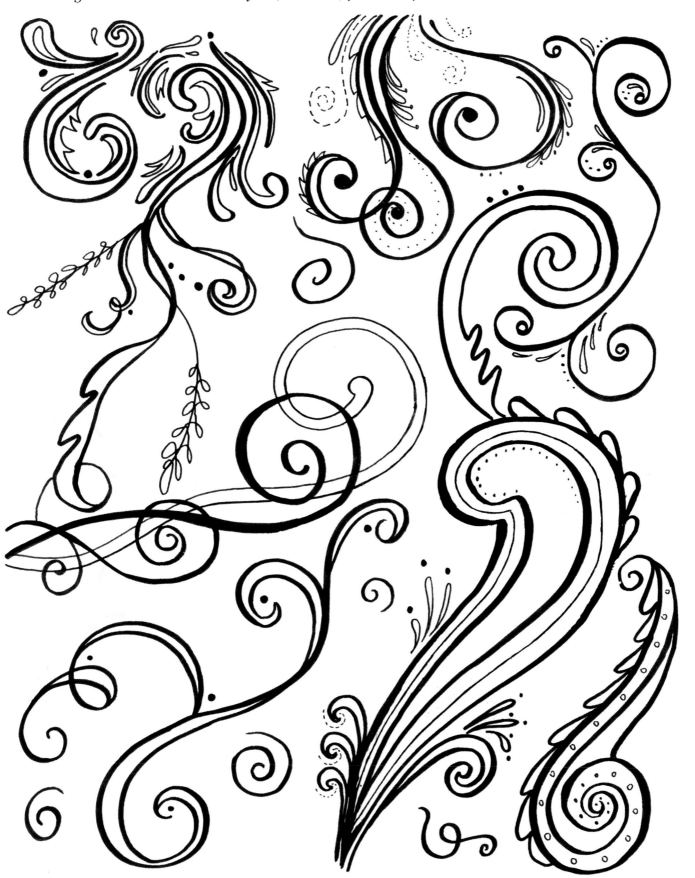

Freehand Hearts and Arrows
by Tonya Bates

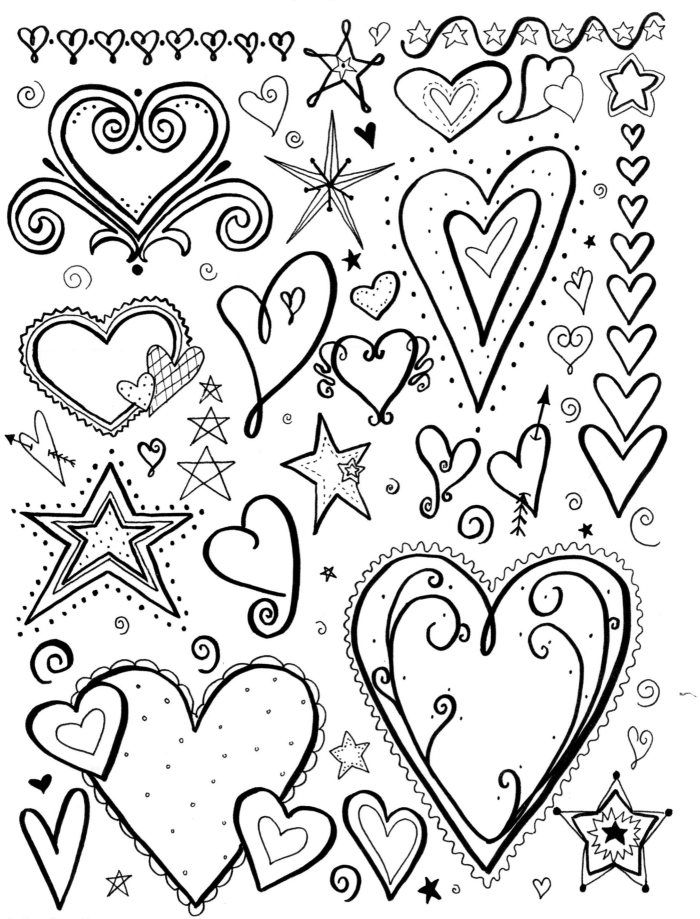

Whether you are scrapbooking a sentiment or creating a birthday card,
these classic motifs point the way to success.
Add movement, style and attitude to your project with these great designs.

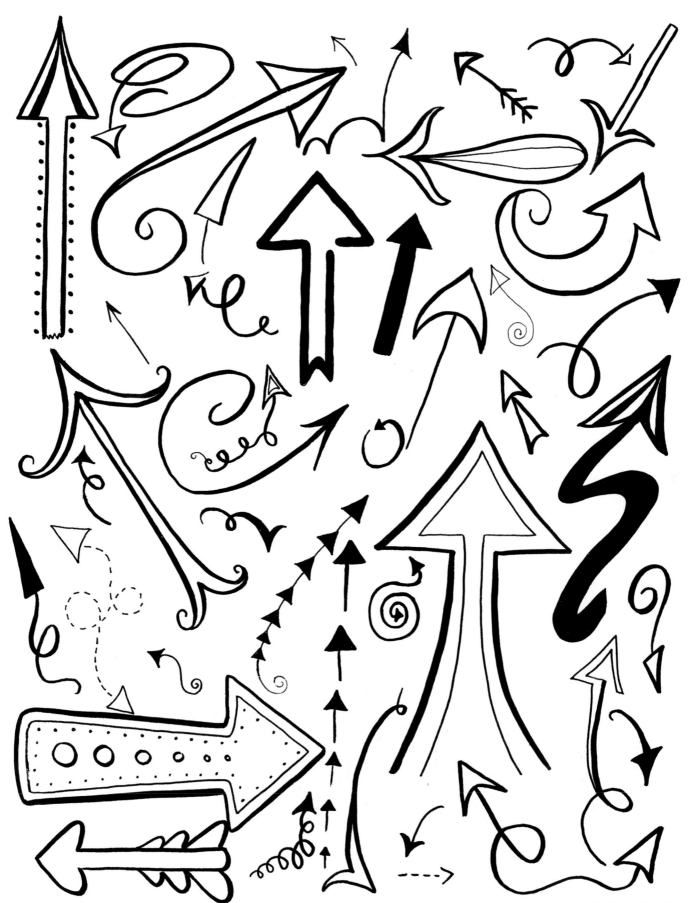

Freehand Doodles and Brads

by Tonya Bates

Salt and pepper, coffee and cream, doodles and brads - some things were just meant to go together.
Doodle on brads with a permanent Black marker. Be sure to let it dry to prevent smudges.

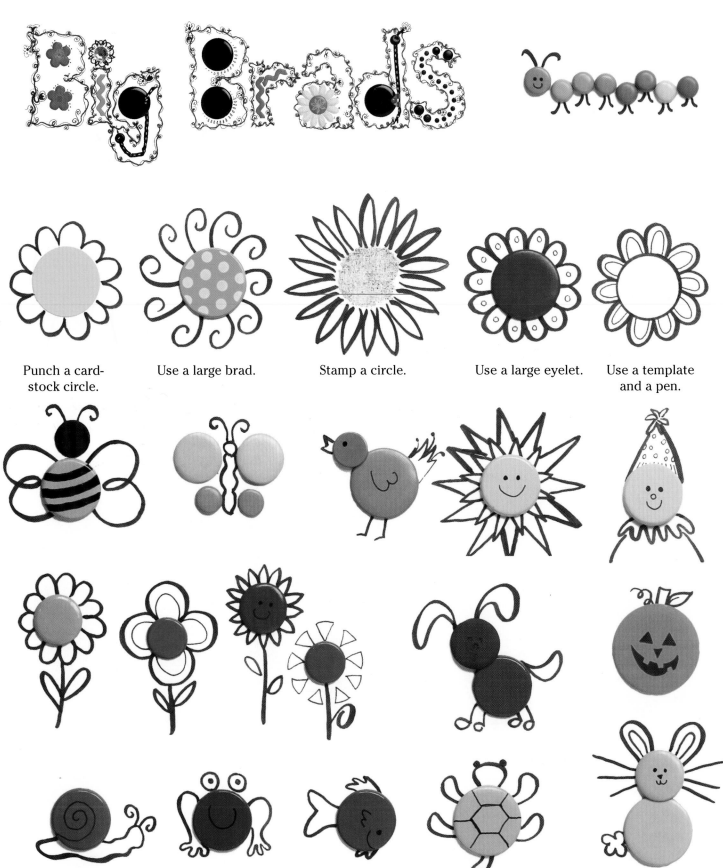

Punch a card-
stock circle.

Use a large brad.

Stamp a circle.

Use a large eyelet.

Use a template
and a pen.

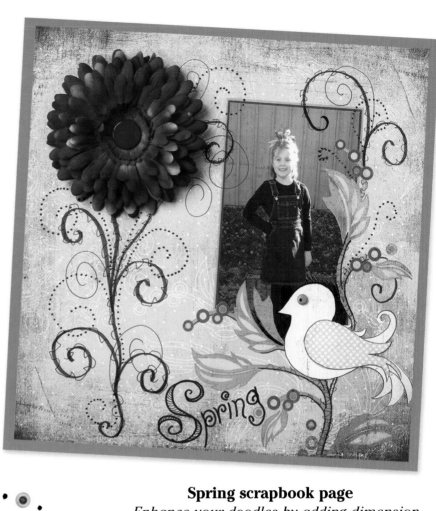

Swirl and Eyelets:
Doodle a scroll with dots, then add small eyelets or brads to the scroll.

Spring scrapbook page

Enhance your doodles by adding dimensional accents. Add a pretty scroll as a flower stem when topped with silk petals held in place with a large brad. Cut the bird from decorative paper and add scrolls to the leaves on the paper.

Decorative papers are from *Cosmo Cricket*

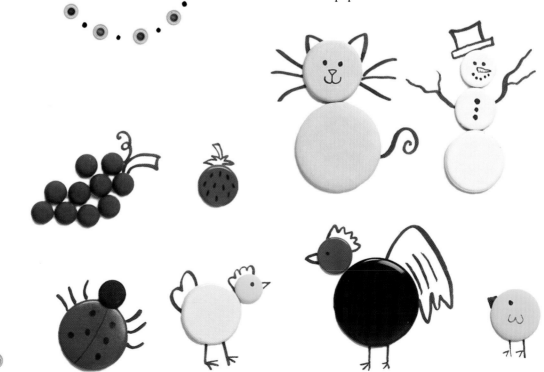

Freehand Alphabet

by Tonya Bates

Use tiny shapes, swirls, dots and patterns to fill letters for a dramatic and intriguing effect.

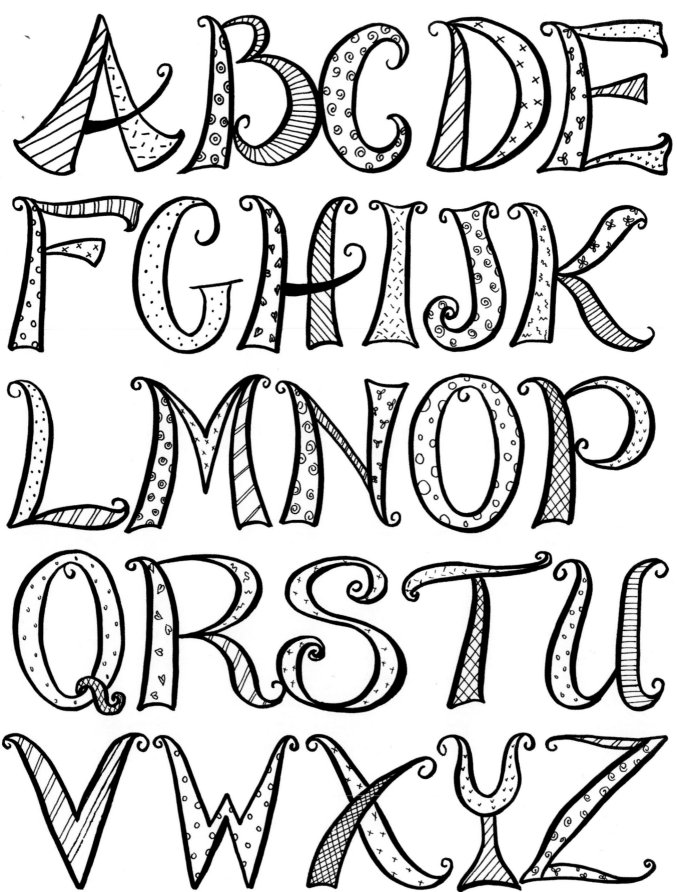

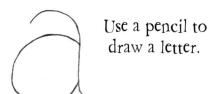 Use a pencil to draw a letter.

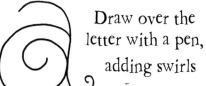 Draw over the letter with a pen, adding swirls

 Erase pencil lines and add fun details.

Embellished Alphabet
Squiggles, dots, triangles, scallops and details add a great look.

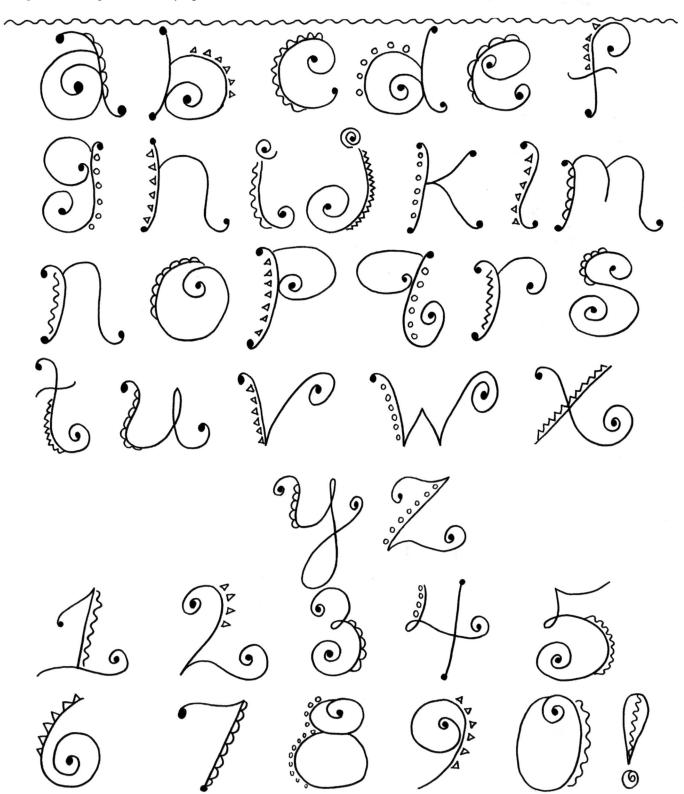

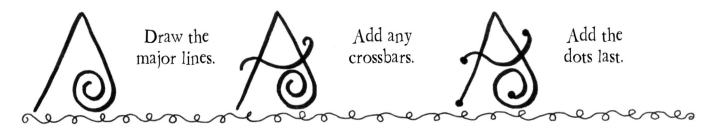

Draw the major lines.

Add any crossbars.

Add the dots last.

Swirly Alphabet

Soft curves give these letters a graceful feeling.

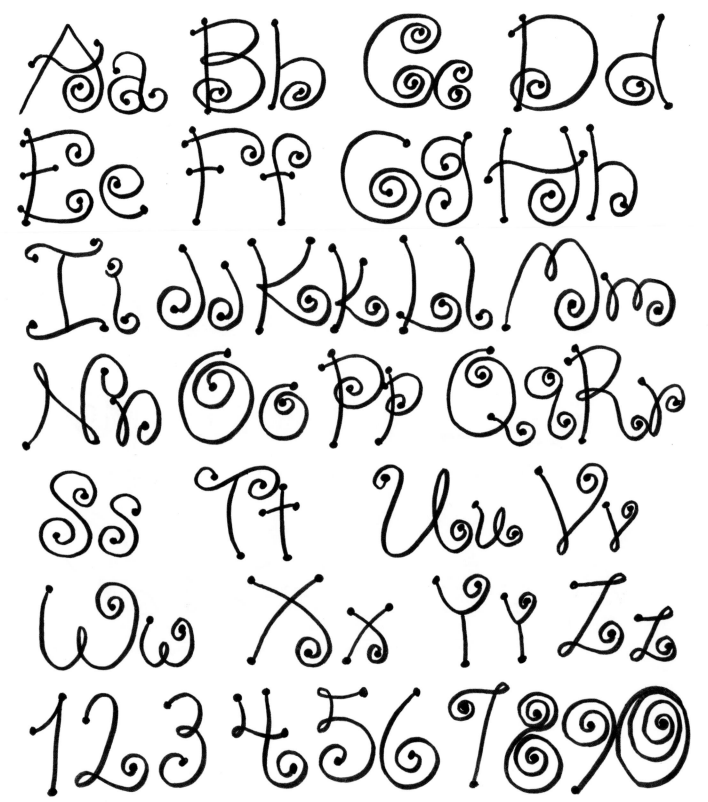

Freehand Fat Alphabet
by Tonya Bates
Make your letters bold and strong, curling the ends.

Aa Bb Cc Dd

Ee Ff Gg Hh

Ii Jj Kk Ll Mm

Nn Oo Pp Qq

Rr Ss Tt Uu Vv

Ww Xx Yy Zz

Draw a cursive letter.

Add a shadow line.

Add small dots.

Shadowed Alphabet *Shadows fade in and out and are never completely whole.*

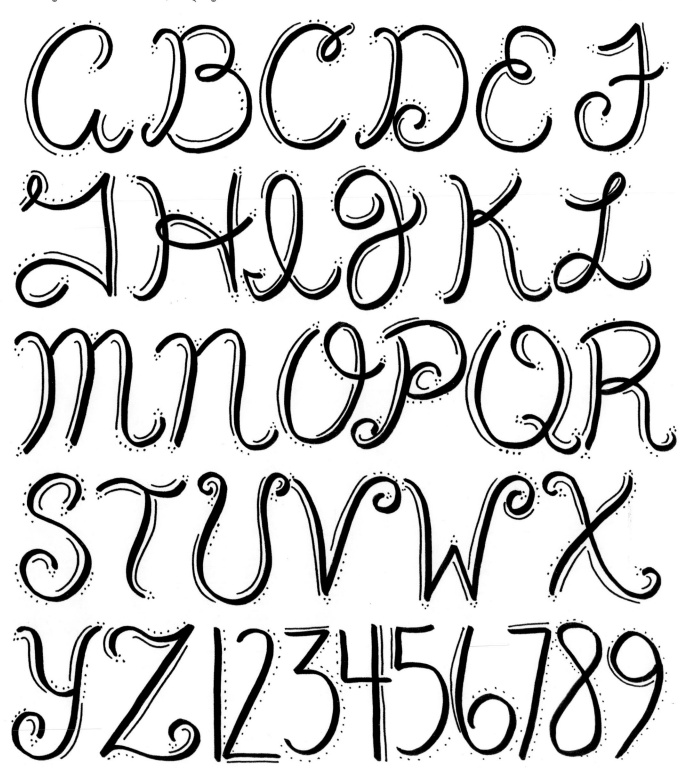

A B C D E F
G H I J K L
M N O P Q R
S T U V W X
Y Z 1 2 3 4 5 6 7 8 9